Color Mixing
in Acrylic

By David Lloyd Glover

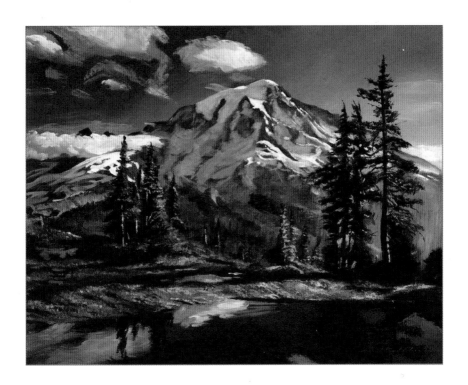

Quarto is the authority on a wide range of topics.
Quarto educates, entertains and enriches the lives of our readers—
enthusiasts and lovers of hands-on living.
www.quartoknows.com

© 2014 Quarto Publishing Group USA Inc.
Published by Walter Foster Publishing,
an imprint of The Quarto Group
All rights reserved. Walter Foster is a registered trademark.
Artwork and photographs © 2014 David Lloyd Glover, except: Photographs on front cover, back cover (top),
and pages 7 ("Butcher's Tray Palette"), 9, 13, 18 (color wheel), 22 (color wheel),
24 (color wheel), and 37 (color wheel) © Shutterstock. Photographs on pages 5
("Acrylic Gesso"), 6, 7 ("Sealed Tray Palette"), 8, and 10–11 © 2014 Elizabeth T. Gilbert.
Paints for color, swatch, and mixing examples provided by Golden Artist Colors, Inc.

6 Orchard Road, Suite 100
Lake Forest, CA 92630
quartoknows.com
Visit our blogs at quartoknows.com

MIX
Paper from
responsible sources
FSC® C016973

Table of Contents

Introduction

As a full time artist, I have become proficient in working with most art media, including watercolor, oil, pastel, gouache, inks, and Conté. Each medium has its own properties, rewards, and—in some cases—degree of difficulty to master. In my opinion, acrylic paint is the most versatile and satisfying of all.

This book offers a solid reference for beginning and intermediate acrylic users alike. Inside you'll find general information on acrylic materials and paints, along with fundamental color theory concepts. You'll also find specific instruction on mixing colors, teaching you how to create the exact hues, tints, tones, and shades you'll need for painting your own works of art.

A note before you begin: If you're like me, you probably flip through instruction books and read them out of order. As a fellow artist, I suggest that you give yourself a break and read this book from beginning to end. This will allow you to develop your color-mixing knowledge from a strong foundation, boosting your confidence as you work toward success.

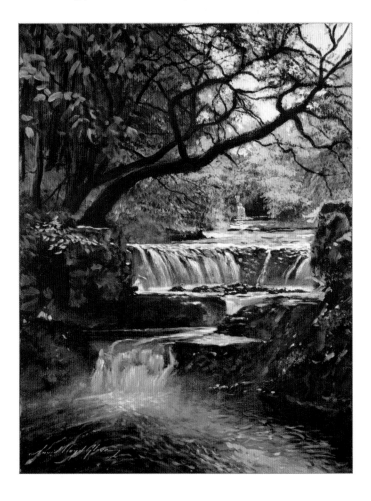

Tools & Materials

Acrylic painting requires fewer materials than oil painting, as it is water-based and easy to clean up. The following pages include the materials I use during my own painting sessions. Remember to always purchase the best quality of materials you can afford, as they often last longer and produce more satisfying results than less expensive options.

Substrates

A true benefit of working with acrylic paint is that it allows you to utilize many different painting substrates (also called "surfaces" or "supports"). This is beneficial for working on a tight budget or if you want to incorporate various textural effects into your work. I most often use canvas, but I also sometimes use canvas panel, wood panel, or paper.

• **Canvas** Many collectors desire a painting that has the look and feel of an oil painting, with a subtle weave visible on the surface. A finished acrylic painting on canvas is virtually indistinguishable from a traditional oil. I typically paint on pre-stretched canvas that comes prepared with a coating of acrylic gesso (see below). If you intend to frame your work, I suggest a canvas with a standard ¾" depth. If not, a canvas depth of 1½" or 2" is ideal.

• **Canvas Panel** These pre-primed, firm, toothy surfaces provide a great solution for painting *en plein air* (outdoors) and are more economical than stretched canvas.

• **Wood Panel** You can purchase pre-primed, ready-to-use wood panels or create them yourself at a low cost. Cut your wood or hardboard (such as masonite) at a lumber supply store, and apply a few layers of gesso on the smooth side. These sturdy surfaces are great for on-location painting.

• **Paper** You can buy thick, sturdy watercolor paper in large pads. Before painting, apply a coat of gesso to create a white, sealed surface that gives your strokes a painterly quality.

Acrylic Gesso
When working with raw canvas, paper, or panels, you'll need to apply "gesso" (also called "acrylic dispersion ground") before painting. This paintlike substance bonds with the substrate to create a white, porous surface that readily accepts paint.

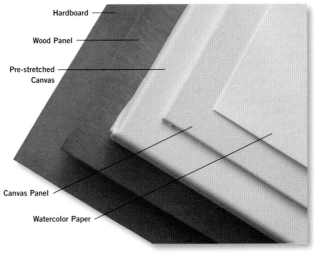

Hardboard

Wood Panel

Pre-stretched Canvas

Canvas Panel

Watercolor Paper

Brushes

Brushes come in a wide variety of shapes and sizes. The long-handled varieties are suitable for acrylics, as you will most likely be working on a vertical painting surface. The most useful and versatile brush shapes are rounds, flats, and filberts. Purchase a few sizes of each for an effective starter set.

Brushes have natural bristles (animal hair), synthetic bristles (man-made fibers), or a blend of both. Some artists find natural bristles to be more resilient, while others prefer the toughness of synthetics. I use natural-bristle brushes; however, acrylics are particularly hard on bristles even when well cared for, so I recommend that you avoid purchasing the finest quality.

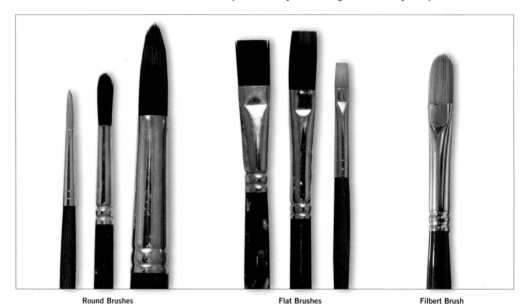

Round Brushes Flat Brushes Filbert Brush

Brush Care

During a painting session, prevent the paint on your bristles from hardening by swishing them frequently in a large container of water. Alternatively, purchase a brush holder that keeps your bristles soaking in water as you work. After a painting session, run your brushes under warm water and work in some brush cleaning soap. Removing all the paint, especially from the base of the bristles, will help your brushes retain their "bounce." Rinse thoroughly, gently press out excess water, and lay them flat to dry.

Mixing Palettes

Any smooth surface can work as a mixing palette. Art supply retailers offer plastic, ceramic, glass, plexiglass, acrylic, and even disposable paper palettes. Choose what works best for you. I prefer to use a butcher's tray, which has a white enameled surface. To clean it, I simply fill it with hot water and, after a few minutes, rub off the old paint.

Some artists use "stay wet" palettes, which are sealed trays that contain a wet sponge. This keeps acrylic paints moist and extends their workability. This is ideal for artists who work in fine detail or with liquid (fluid) acrylics. To keep my palette colors moist and active in my butcher's tray, I simply use a spray bottle of filtered water to periodically mist the palette surface very lightly; a little practice will lead you to just the right amount of spritzing for your blending style.

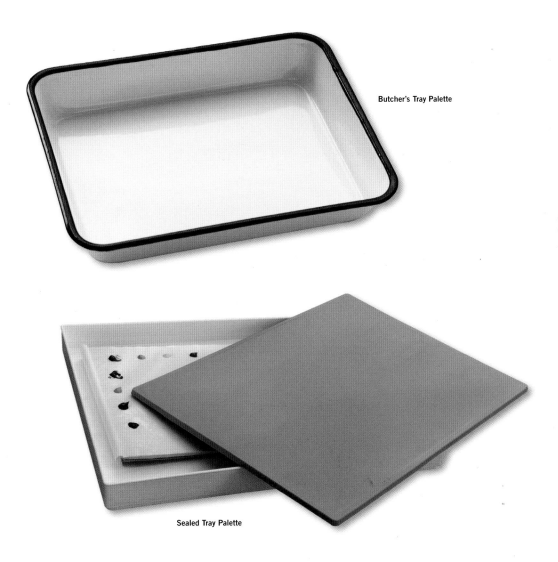

Butcher's Tray Palette

Sealed Tray Palette

Palette Knives

For mixing small quantities of paint, a small, old brush is sufficient. However, mixing large quantities of paint calls for a palette knife. These tools have flexible, metal blades that help you scoop, spread, and mix paint. Some artists use these tools to apply paint to the canvas in thick, buttery strokes. Knives designed specifically for applying paint are referred to as "painting knives."

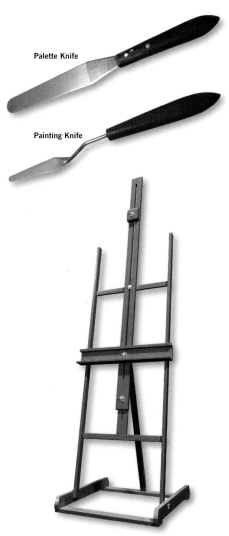

Palette Knife

Painting Knife

A palette knife can help you gently mix paint colors together on your palette. To mix smaller amounts of paint, using an old brush can be more effective.

Additional Painting Tools

- Easel or support for your painting surface
- Paper towels or rags for cleanup
- Jars of water for paint mixing and brush rinsing
- Spray bottle of water
- Acrylic mediums (optional; see page 11)

▶ An H-frame easel offers sturdy support for canvases while you paint in the studio. Alternatives include a space-saving tabletop easel or portable box easel for painting outdoors.

Cleanup

One of the benefits of using acrylic over oil is the easy cleanup. Use soap and water to eliminate it from your hands, and use brush soap and water to clean your brushes. However, remember that acrylic will not come out of clothing, so wear old clothes or an apron while you paint.

Acrylic Paint

Acrylic bears a number of positive qualities for artists when compared to other media. The paint is odor-free and nontoxic. The colors are rich, and the paint dries quickly and permanently to a flexible film, allowing you to paint over areas without muddying up previous layers. Its water-based composition, which is essentially pigment mixed with acrylic polymer emulsion, allows you to thin and blend the paint simply with water.

Brands & Grades

Art supply retailers carry a wide array of paint brands. The standards of quality are high among the names you see often, such as Winsor & Newton™, GOLDEN®, Liquitex®, Daler-Rowney®, Lukas®, and others. Whatever you choose, purchase the same brand of colors for your entire palette. Color and consistency vary among manufacturers; sticking with one brand yields more predictable results. For the color samples in this book, I use GOLDEN Acrylics.

There are two grades of paint available: student grade and artist grade. Artist-grade acrylics are for professionals who desire a high-quality, painterly look. With rich color saturation and a buttery feel, this grade most closely resembles oil paint. Student-grade acrylics use less expensive pigments, which can affect the way colors mix; sometimes the results aren't as predictable. Painters who prefer to use colors straight from the tube find student-grade paints useful.

Types of Acrylic

Acrylic paint is available in tubes, tubs, squeeze bottles, and pots. There are several different types of acrylic to choose from, depending on your painting style. Below are the types available to artists today; however, note that I use basic acrylic paint for the examples in this book.

 Basic Acrylic Paint This paint is creamy and gel-like in consistency.

 Heavy Body Acrylic Paint This thick paint feels like traditional oil paint and retains brushstrokes for a painterly style.

 Craft Acrylics This paint works well on a wide variety of surfaces and comes in a large range of pre-mixed colors; therefore, it is not specifically intended for color mixing and blending.

 Liquid or Fluid Acrylics This thin but still highly pigmented paint settles to a smooth finish and can yield a number of flowing effects.

 Acrylic Inks These very thin, permanent, and vibrant inks allow for fluid, watercolor-like effects.

Artist's Tip

Student-grade paints are a cost-effective way to cover expansive areas of blank canvas for colored grounds and underpaintings.

Acrylic Mediums & Additives

Mediums and additives are substances that alter the characteristics of paint, such as the sheen or consistency. As we've discussed, acrylic is a water-based medium that thins easily with water; therefore water is the simplest and cheapest additive available. However, additional mediums for acrylic are available to artists in the form of gels. Heavy-body gel medium thickens your paints and allows your strokes to form peaks; softer gel mediums thin and extend the paint so you can cover more while using less paint. Some mediums and additives add gloss, sparkle, or interesting textural effects; take a look at the varieties available and experiment.

Helpful additives for some painters are flow improver, retarder, and blending medium. Flow improver thins paint while preserving the strength of its color, whereas a retarder slows the drying time of paint. Retarders give artists more time to blend and work with the colors on their palettes. Blending mediums subtly thin and soften paint to increase its blending ability.

Soft gels (left), regular gels (center), and heavy gels (right) extend acrylic paints while altering their consistency. The heavier the gel, the higher the peaks you can achieve by tapping the paint with a palette knife.

Artist's Tip

To minimize pigment usage, it's best to add paint to a medium rather than a medium to paint.

Setting Up a Palette

Limiting your palette will help you create unity in a painting. As a professional landscape painter, I prefer a simple palette of seven paint colors. However, there are a vast array of pigments available, which can help you develop a specialized palette if needed. Portrait painters might use several premixed hues that are useful for skin, hair, and eyes; floral painters might select colors that closely match the particular flowers in their paintings. An effective starter palette for learning color basics is as follows:

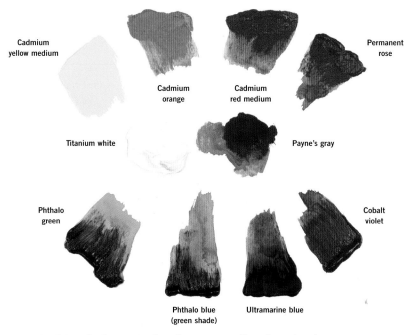

Cadmium yellow medium

Cadmium orange

Cadmium red medium

Permanent rose

Titanium white

Payne's gray

Phthalo green

Cobalt violet

Phthalo blue (green shade)

Ultramarine blue

The pigments in this palette are vivid and interact well with each other. You can create any color you need with these colors. Once you are fully acquainted with the basic colors in your palette, try adding a few additional colors that might offer you shortcuts for mixing. You may find the following colors useful:

Cerulean blue Yellow ochre Green gold Burnt sienna Dioxazine purple

Artist's Tip

Purchase a large tube of titanium white, as you will likely use this paint more than any other in your palette.

Color Theory

A basic understanding of color theory is an essential stepping-stone to creating successful paintings. When you see a beautiful painting in a museum, the impact often comes from the use of color more than detail or form. Color stimulates our eyes and brains with an emotional response. On the following pages, learn basic color terminology and how color relationships can help you communicate as an artist.

The Color Wheel

A pigment color wheel shows color relationships in a circular diagram and serves as a valuable tool for color mixing. The *primary colors*—red, yellow, and blue—cannot be mixed using any other colors. They sit at equidistant points around the circle. Lying between the primaries are the *secondary colors*—orange, purple, and green. Each secondary is a mix of two primaries. For example, green is a mix of yellow and blue, purple is a mix of red and blue, and orange is a mix of yellow and red. *Tertiary colors* are a mix of a primary and an adjacent secondary, such as blue-green.

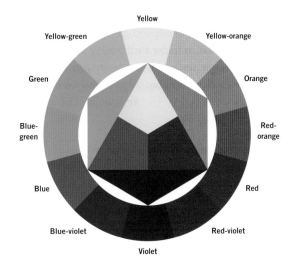

Yellow
Yellow-green · Yellow-orange
Green · Orange
Blue-green · Red-orange
Blue · Red
Blue-violet · Red-violet
Violet

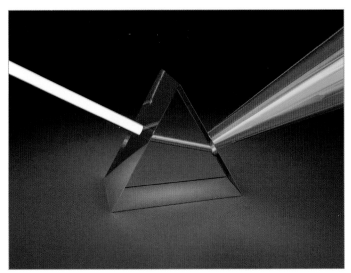

Color Spectrum Using a glass prism to refract a ray of natural sunlight onto a nearby white surface, you can see the primaries and secondaries quite vividly. If you were to take this natural rainbow spectrum and bring the ends together, so that the reds touch the violets, you would get a diagram like the color wheel above.

The acrylic paints above cover the color spectrum quite well: quinacridone magenta, cadmium red, cadmium orange, cadmium yellow, phthalo green, phthalo blue, ultramarine blue, dioxazine purple.

Complementary Colors Colors that sit directly opposite each other on the color wheel (such as red and green) are complementary. When placed next to each other in a painting, they appear more intense than when alone. Artists often use complementary colors to create a clear focal point. (See the painting on page 16.)

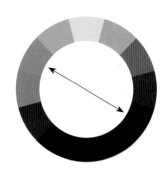

Analogous Colors Colors that sit adjacent to one another on the color wheel (such as yellow-orange, orange, and red-orange) are analogous. When used together in a painting, these colors create a sense of harmony and unity.

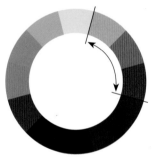

Monochromatic Colors These variations of color are created by mixing a single color with varying quantities of white and black. Paintings in monochromatic color are generally soothing and use contrasts in value as the main tool for directing the viewer's eye toward a focal point.

Color Scheme A selection of colors (also called a "palette of colors") used together in a work for a specific goal is called a color scheme. For example, a complementary color scheme might feature two dominant complementary colors—such as blue and orange—for a high-energy, high-contrast painting.

14

Hue, Saturation & Value

A color can be described using three key properties: hue, saturation, and value. *Hue* refers simply to the color itself (such as turquoise or lime green), *saturation* refers to the color's intensity, and *value* refers to the lightness or darkness of the color. Each color property plays a role in how the color fits into a work of art and how it relates to the surrounding colors.

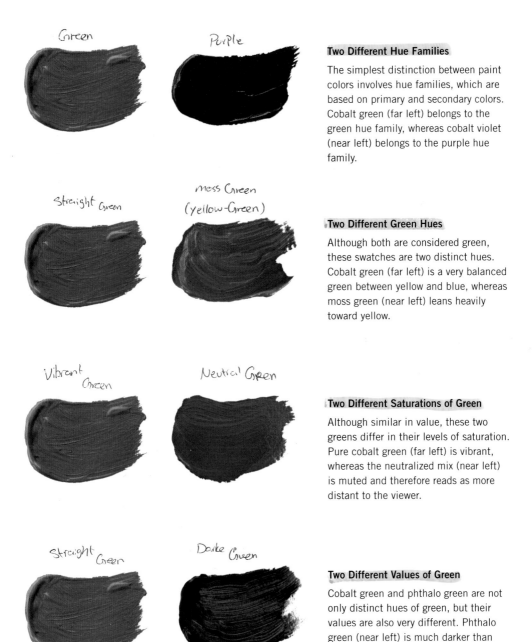

Green Purple

Two Different Hue Families

The simplest distinction between paint colors involves hue families, which are based on primary and secondary colors. Cobalt green (far left) belongs to the green hue family, whereas cobalt violet (near left) belongs to the purple hue family.

Straight Green moss Green (yellow-Green)

Two Different Green Hues

Although both are considered green, these swatches are two distinct hues. Cobalt green (far left) is a very balanced green between yellow and blue, whereas moss green (near left) leans heavily toward yellow.

Vibrant Green Neutral Green

Two Different Saturations of Green

Although similar in value, these two greens differ in their levels of saturation. Pure cobalt green (far left) is vibrant, whereas the neutralized mix (near left) is muted and therefore reads as more distant to the viewer.

Straight Green Darke Green

Two Different Values of Green

Cobalt green and phthalo green are not only distinct hues of green, but their values are also very different. Phthalo green (near left) is much darker than cobalt green's middle value (far left).

Hue

Because "hue" refers to a specific color, there are a number of terms that can describe a hue. For example, yellow is a hue and blue is a hue. However, not all yellows are the same hue; lemon yellow (which leans blue) is a different hue than cadmium yellow (which leans red). Think of "hue" as a specific name for a color.

Saturation

Pigments are most intense and appear most saturated straight out of the tube. To desaturate or soften a color, try adding white (which creates a tint of the color), gray (which creates a tone of the color), and black (which creates a shade of the color). Rather than using black, I often choose to mute a saturated color by adding a touch of Payne's gray. I sometimes create tints by thinning the acrylic with water. You can also desaturate a color by adding a small amount of a complementary color. For example, try toning down purple with a dab of yellow and vice versa.

Artists can use the saturation of colors to draw the eye to the focal point of a painting. Because the eye is drawn to bolder, more intense colors, you can guide the viewer by surrounding your focal point with less saturated colors. Also, keep in mind that nature offers a balance of saturated and unsaturated colors; using pure and vibrant colors throughout an entire painting will yield unrealistic results.

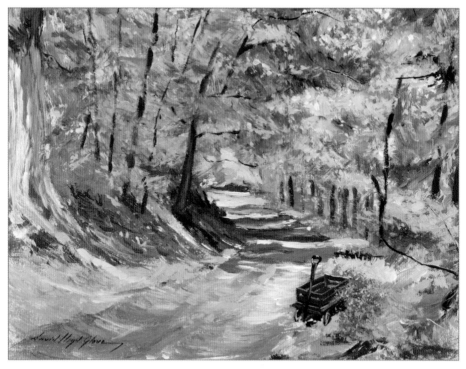

In this painting, I made the wagon the focal point by using a highly saturated red. I surrounded it with greens that I softened and desaturated with white, and I muted the colors of the tree trunk and pathway using white and Payne's gray. I also mixed the earth tones using cadmium orange and green rather than a more saturated burnt sienna. These actions keep any other color from competing with the red of the wagon.

Value

The value of a paint refers to its lightness or darkness regardless of color. If you squint at the color wheel on page 13, you'll notice that each color of the spectrum has an inherent value. For example, yellow is the lightest and purple is the darkest. Within each color, however, you can create a wide range of values. Imagine the deepest, darkest blues of the ocean compared to the lightest blue of the sky's horizon.

Value is an important tool in composing a painting because the eye readily reads values. A work with contrasting values is more interesting to look at than a work made entirely of light pastels or dark colors. Value is also a tool for guiding the viewer's eye; it's a good idea to place your darkest darks and your lightest lights within the focal point of your painting.

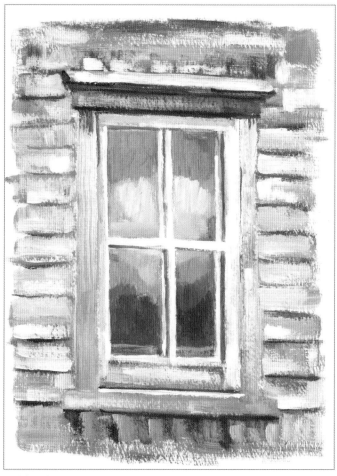

In this painting, I've varied the values of the sky reflection in the window. I chose cerulean blue as my main sky color; then I mixed in white for lighter values and Payne's gray for darker values.

Color Temperature

The color wheel can be divided into two halves: warm and cool colors. Warm colors include reds, oranges, and yellows, whereas cool colors include blues, purples, and greens. In essence, the colors are categorized in this manner due to how they feel to the viewer. For example, warm colors feel warm because they invoke associations of fire; cool colors feel cool because they invoke associations of water and ice.

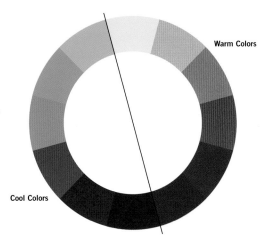

Warm Colors

Cool Colors

Warm & Cool Color Schemes

If the subject calls for it, you might choose to dominate a painting's palette with either warm or cool colors. The temperature of your palette has a significant effect on the mood of a piece; warm pieces are more energetic and unsettling, whereas cool pieces often impart serenity and calm.

Notice that the dominantly warm painting at right includes some cool tones (the blues in the lake), which make the reds and yellows appear even richer. Similarly, the dominantly cool painting above includes a bit of warmth (the yellow accents on the embankments) to make the blues appear even cooler.

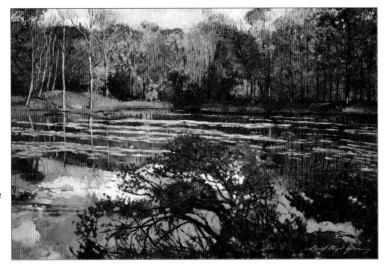

Color & Space

Warm and cool colors behave differently when used within a painting. Warm colors tend to advance toward the viewer, giving the impression of closeness, whereas cool colors tend to recede. With this dynamic in mind, consider accenting your foregrounds with warmth and cooling your backgrounds to enhance a painting's sense of distance.

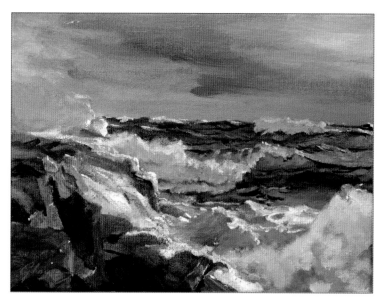

In this seascape, the warm reds of the setting sun reflected on the rocks offer an effective focal point and foreground. The cool blues and greens of the ocean push the waves into the distance. The warm-leaning hues of the sky create another plane of distance, creating an almost three-dimensional effect.

Suggesting Time of Day

Color temperature is an excellent way to communicate time of day to the viewer. The morning generally has a cool light that produces warm shadows; as the day progresses toward sunset, the light becomes warmer and the shadows become cooler.

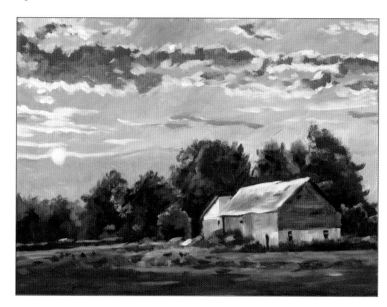

This pastoral painting uses color temperature to communicate both time of day and distance. The warmth of the sky at sunset complements the cooler shadows of the trees and barn. Warm yellow strokes in the foreground bring the earth forward while the cooler purples in the background push the trees into the distance.

Color & Nature

Fellow artists often ask how I can use such a variety of vivid and saturated colors while still creating a scene that appears natural to the eye. Truthfully, I have never found the answers in a book. Color use is a mix of skill, practice, and intuition. However, I always rely on nature as my guide. I make a point to get out of the studio and observe my locations in person, and I urge you to do the same. See how many different colors you can find in a big green tree. You'll likely find that it is not all green but an amalgam of tones and hues that give the tree form and a sense of time and place.

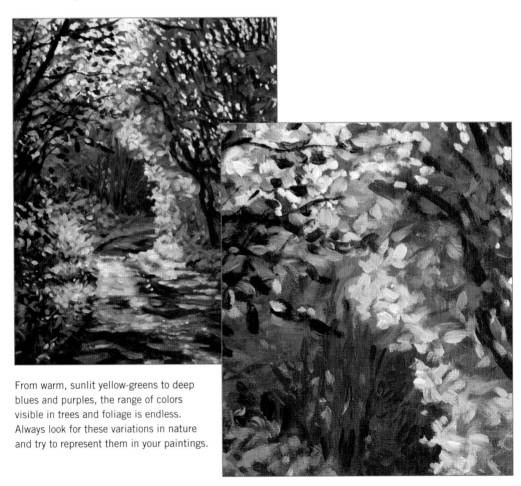

From warm, sunlit yellow-greens to deep blues and purples, the range of colors visible in trees and foliage is endless. Always look for these variations in nature and try to represent them in your paintings.

Artist's Tip

To match a color when painting outdoors, mix the paint on your palette, load a brush, and hold it up against your scene. If the color on the brush seems to disappear, you have mixed the correct color.

Pigment Properties

Pigment refers to the particles that give a paint its color. They are classified as *inorganic* (from earth or non-carbon substances) or *organic* (carbon compounds). Many pigments in use today are synthetic organic pigments manufactured in a laboratory.

Transparency

Pigments appear transparent or opaque in varying degrees. Great for suggesting depth in backgrounds, transparent pigments allow more light to pass through the paint and reflect the surface beneath to create luminous results. Opaque pigments block light to offer more coverage and create a more solid appearance, making them best for foregrounds and highlights.

In this example, view crimson (transparent) over black to cadmium red (opaque) over black.

Staining

Pigments can be staining or non-staining. Staining pigments (which are usually strong tinters as well) permanently color the fibers of your paper or canvas, whereas non-staining pigments can be wiped or washed away. Staining knowledge is helpful for artists who work in thin layers and use wiping techniques.

In this example, view rose madder (a staining pigment) versus burnt sienna (a non-staining pigment). Each has been wiped away to reveal the affected surface beneath.

Tinting Strength

Some pigments, such as phthalo blue, are considered strong pigments with high tinting power. These pigments can go far, even when diluted in mixes. Knowing the tinting strength of your pigments can help you effectively estimate the best ratio when mixing a desired color.

A B

In this example, highly tinting phthalo blue overpowers cadmium lemon yellow (A) when mixed in equal proportions. Ultramarine blue mixed with cadmium lemon yellow (B) creates a more balanced green.

Safety Warning

Cadmium pigments contain toxic metals, so take extra measures to minimize contact with these paints. Consider using a hue variety instead.

Working with Primaries

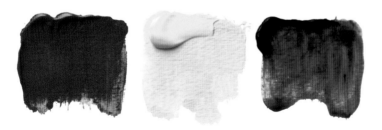

Bold and basic, the primaries are the fundamental colors of the color wheel. You can blend them to create secondary colors, tertiary colors, and neutral colors, but you cannot create primaries using other colors. In this section, you'll discover information on pigment properties, mixing secondaries, manipulating primaries, and achieving a wide range of tones and hues. You'll also see finished works with each dominating color and learn how color can affect the mood of a painting.

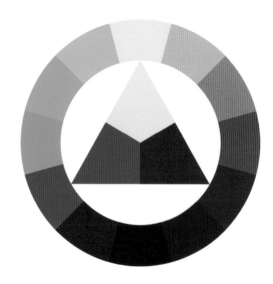

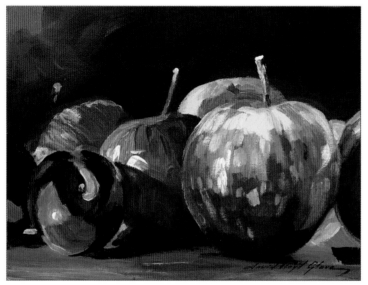

Using predominantly primary colors to create a work of art yields dynamic and accessible results. Because they are equidistant on the color wheel, they create a *triadic* color scheme.

Using Primaries to Create Secondaries

You may know that red + yellow = orange, blue + yellow = green, and blue + red = purple. But you may not know which pigments to mix to achieve your desired results. Below and on the following page are basic guidelines for creating secondaries, along with a few sample mixes to get you started.

cadmium yellow + cadmium red + titanium white

Mixing cadmium yellow, cadmium red, and titanium white produces a wide range of basic oranges. If desired, you can purchase pre-blended cadmium yellow and cadmium red in a tube called "cadmium orange."

phthalo blue + cadmium red + titanium white

A 1:1 mix of phthalo blue and cadmium red yields a rich violet. Adjusting the proportions and adding white creates a beautiful variety of purples and mauves.

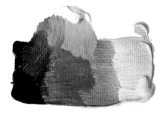

cadmium yellow + phthalo blue + titanium white

Blends of cadmium yellow and phthalo blue produce a range of bold and vibrant greens. Create even more variety by softening with titanium white.

Mixing Guidelines

When mixing secondaries for a painting, consider the following:

- Mixing colors that lean toward each other on the color wheel will create vibrant results.
- Mixing colors that lean away from each other on the color wheel will create muted results.

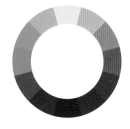

Both vibrant and muted colors have a place in painting, so it's best to master both styles of mixing to find color combinations that suit your subject and style.

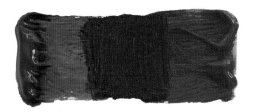

Mixing a Bright Purple Ultramarine blue (a red-leaning blue) mixed with crimson red (a blue-leaning red) creates a vibrant purple.

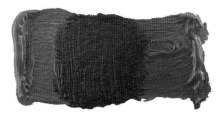

Mixing a Muted Purple Cerulean blue (a yellow-leaning blue) mixed with cadmium red (a yellow-leaning red) results in a dull, earthy purple.

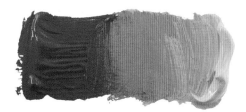

Mixing a Bright Orange Cadmium red (a yellow-leaning red) mixed with cadmium yellow dark (a red-leaning yellow) creates a warm, bright orange.

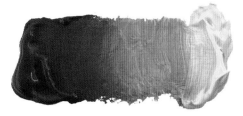

Mixing a Muted Orange Crimson red (a blue-leaning red) mixed with cadmium lemon yellow (a blue-leaning yellow) produces slightly cooler results.

Working with Reds

Red is a warm, powerful color often associated with passion, love, anger, and danger. In this section, learn about available pigments and how to manipulate this color to suit your artistic needs.

> *The paints below are common paint colors shown in masstone (with thickness), undertone (spread thinly), and mixed with white. Note that every paint color varies somewhat between manufacturers.*

Common Red Pigments

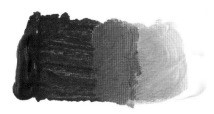

Crimson is a bright, rich, slightly cool red. It is generally a semi-transparent paint with a strong stain.
Alternatives/other names: alizarin crimson, alizarin crimson hue, permanent alizarin crimson

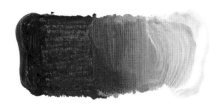

Permanent rose is a cool, highly staining, transparent red that can appear almost magenta. When blended with white, permanent rose creates beautiful, clear pink tones.
Alternatives/other names: quinacridone rose

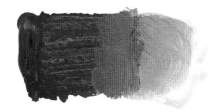

Cadmium red is a warm, yellow-leaning red that is opaque and low staining.
Alternatives/other names: cadmium red hue, cadmium red light, cadmium red medium, cadmium red dark

Other Red Pigments

Pyrrole red: This vibrant, yellow-leaning red pigment is semi-opaque with a high-staining quality.

Napthol red: This bright, yellow-leaning red pigment is also semi-opaque with a high-staining quality.

Rose madder (genuine): This violet-leaning *lake* pigment is transparent and non-staining. (A lake pigment is created by fixing a dye to a powder and mixing with binder to create paint.)

Warming Reds

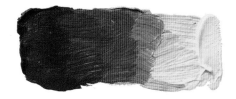

Warm your reds by adding touches of yellow. In this example, I warmed cadmium red with cadmium yellow.

Cooling Reds

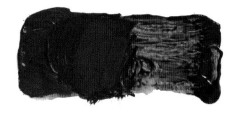

Cool your reds by adding touches of blue. In this example, I cooled cadmium red with phthalo blue.

Neutralizing Reds

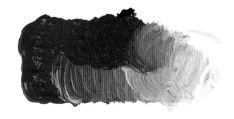

To soften and neutralize a red pigment, such as cadmium red, add small amounts of Payne's gray and, if desired, white. The resulting muted reds work well for portrait flesh tones. Payne's gray is pigment dense, so use it sparingly as you introduce it to the mix.

You can also neutralize red by blending it with a small amount of its complementary color, green. In this example, I neutralized red magenta with green gold to produce an earthy red-brown. As with Payne's gray, introduce the complementary color sparingly.

Painting with Reds

To create this bright, middle-red rose, I mixed and applied several red shades to describe the dimension, shape, and lighting. I used cadmium red as the base, blending with titanium white for the lights and dioxazine purple for the shadows. The complementary green leaves make the red appear even more vibrant.

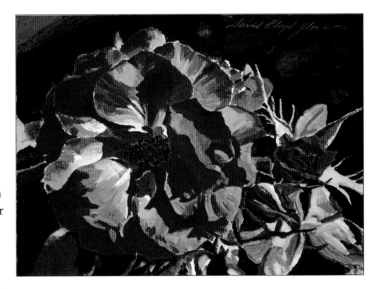

Artist's Tip

Many people have difficulty perceiving red and its subtleties due to color blindness. In this case, premixed colors can be very helpful.

Mixing Pinks

Painting florals will often call for mixing pinks. You can achieve a range of lively, true, and pure pinks by mixing titanium white with red-violet pigments, such as quinacridone magenta or rose madder. However, you can use other red pigments for warmer varieties.

Rose madder mixed with titanium white produces cool, vibrant pinks.

Cadmium red mixed with titanium white creates warm pinks.

Samples of Red Mixes

Below is a selection of mixes that are helpful when working with reds. Each mix is accompanied by a "recipe," allowing you to re-create any swatch desired. To create the color samples, I used titanium white for "white."

1 part cadmium red medium +
1 part cadmium orange

1 part quinacridone magenta +
1 part lemon yellow

2 parts crimson +
1 part ultramarine blue

1 part quinacridone magenta +
1 part phthalo green +
2 parts white

1 part quinacridone magenta +
1 part lemon yellow +
2 parts white

3 parts crimson +
1 part ultramarine blue +
3 parts white

1 part quinacridone magenta +
1 part phthalo green +
8 parts white

2 parts vermillion +
1 part cadmium yellow medium

3 parts lemon yellow +
1 part cadmium red medium

2 parts cadmium red medium +
1 part cobalt violet

2 parts quinacridone magenta +
1 part cobalt violet +
1 part white

3 parts lemon yellow +
1 part cadmium red medium +
1 part white

Working with Yellows

Yellow is a warm, energetic color often associated with sunshine and joy. On the following pages, learn about available pigments and how to manipulate this color to suit your artistic needs.

> *The paints below are common paint colors shown in masstone (with thickness), under-tone (spread thinly), and mixed with white. Note that every paint color varies somewhat between manufacturers.*

Common Yellow Pigments

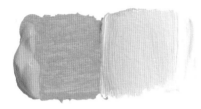

Cadmium yellow is a warm, red-leaning yellow. It is a low-staining, opaque pigment that creates muted yellow tints when mixed with white. *Alternatives/other names: cadmium yellow hue, cadmium yellow light, cadmium yellow medium, cadmium yellow dark*

Cadmium lemon yellow is a bright, blue-leaning yellow. Semi-opaque and staining in nature, this paint creates cool tints when mixed with white. *Alternatives/other names: cadmium lemon, cadmium lemon light, cadmium lemon yellow pure*

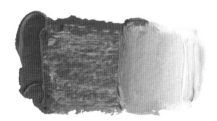

Yellow ochre is a warm, deep-yellow earth tone. It is a low-staining, opaque pigment that yields soft browns and even pinks when mixed with white.

Other Yellow Pigments

Aureolin: This primary yellow is transparent and low-staining.

Naples yellow hue: This soft, rosy yellow is low-staining and semi-transparent.

New gamboge: This bright yellow is transparent and low-staining.

Deepening & Neutralizing Yellow

Maintain the richness of your yellows by deepening with the warm side of the color wheel, such as with oranges and reds. In contrast, using blues instantly turns yellows into greens. However, mixing in small amounts of purple (the complementary color to yellow) can mute and neutralize yellows nicely.

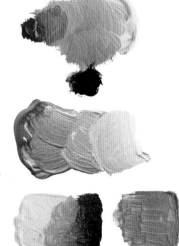

To deepen and neutralize cadmium yellow, I begin by blending in a small amount of cadmium red to create a yellow-orange. Then I add a very small amount of dioxazine purple.

Adding white to yellow ochre softens the hue to create a variety of warm earth tones, which are wonderful for landscapes and portraits.

To paint shadows of yellow, deepen the yellow using cobalt violet or dioxazine purple. These mixes will yield natural, deep-yellow tones.

Mixing Specific Yellows

To mix a hue similar to yellow ochre, blend ultramarine blue, titanium white, cadmium yellow, and touches of cadmium orange and dioxazine purple.

To create a lemon yellow hue, mix equal parts cadmium yellow and titanium white. Introduce a very small amount of phthalo blue to slightly cool the yellow pigment into a lemon yellow.

Artist's Tip

Black is a non-color, so it is not very effective for neutralizing a color. Black often overpowers any color you mix with it, so introduce it sparingly. In particular, I recommend not mixing black with yellow, as it dulls yellow dramatically and results in muddy, greenish hues.

Painting with Yellows

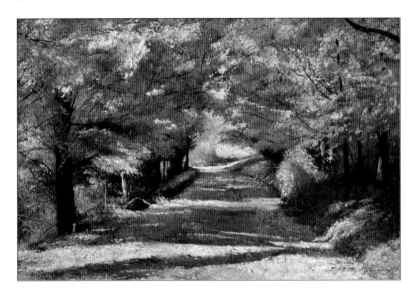

Paintings dominated by yellows naturally result in warm paintings. This landscape scene is intended to highlight the warm golds of autumn leaves on a sunny day. Every color in this painting is in the warm hemisphere of the color wheel, with the exception of the cool blue sky peeking through the trees. I used only primary colors and titanium white, along with dioxazine purple to create shadows.

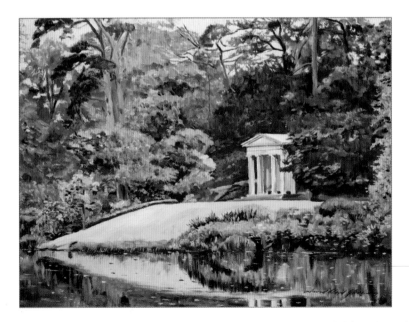

I used yellows predominantly when mixing for this painting of an English lake. I kept the greens to the warm side of the wheel by mixing them, rather than using green paints from the tube. I also used a larger proportion of warm yellows in my mixes than blues, reds, and whites.

Samples of Yellow Mixes

Below is a selection of mixes that are helpful when working with yellows. Each mix is accompanied by a "recipe," allowing you to re-create any swatch desired. To create the color samples, I used titanium white for "white."

1 part cadmium yellow light +
2 parts white

2 parts white +
1 part cadmium yellow dark

2 parts white +
1 part yellow ochre

2 parts cadmium yellow light +
1 part white

1 part white +
2 parts cadmium yellow dark

1 part cadmium yellow dark +
1 part yellow ochre +
1 part white

2 parts white +
3 parts cadmium yellow light +
1 part cobalt violet

3 parts cadmium yellow dark +
1 part cobalt violet

1 part cadmium orange +
3 parts lemon yellow +
1 part white

2 parts white +
3 parts cadmium yellow light +
1 part cobalt violet +
1 part quinacridone magenta

3 parts cadmium yellow dark +
1 part quinacridone magenta +
1 part cobalt violet

4 parts cadmium lemon yellow +
1 part white +
1 part phthalo green

Working with Blues

Blue is a cool, soothing color often associated with air, water, sky, and melancholy. In this section, learn about available pigments and how to manipulate this color to suit your artistic needs.

The paints below are common paint colors shown in masstone (with thickness), undertone (spread thinly), and mixed with white. Note that every paint color varies somewhat between manufacturers.

Common Blue Pigments

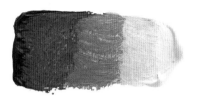

Ultramarine is a deep, warm, red-leaning blue pigment that is low-staining and semi-transparent. Once made from the semi-precious stone lapis lazuli, this paint pigment is now made synthetically.
Alternatives/other names: ultramarine blue, ultramarine blue hue, French ultramarine

Phthalo blue is a rich, highly staining, transparent pigment. It is available as both a red-leaning and green-leaning pigment.
Alternatives/other names: phthalocyanine blue (full name), phthalo blue (green shade), and phthalo blue (red shade)

Cerulean blue is a semi-transparent, low-staining blue that leans green. Blending it with titanium white creates the soft, warm blue-greens favored by the Impressionists. It is not as pigment dense as other blues, such as phthalo blue.
Alternatives/other names: cerulean blue hue

Other Blue Pigments

Cobalt blue: This pigment is semi-transparent with a low-to-medium staining ability.

Prussian blue: This deep blue pigment is transparent and staining. It has largely been replaced by phthalo blue on the palettes of today's artists. The paint is also known as Parisian blue, Chinese blue, Berlin blue, and iron blue.

Manganese blue: This cool, green-leaning blue pigment is transparent and high-staining.

Warming Blues

To create warm blues, it's best to start with a warm, red-leaning blue pigment, such as ultramarine. To add warmth, mix in small amounts of cobalt violet, softening and lightening with white.

Softening & Neutralizing Blues

Rather than using a black pigment, adding a small quantity of Payne's gray to ultramarine (above left) and cerulean (above right) neutralizes blues effectively without overly dulling. Blending in titanium white creates soft, blue-gray tones.

Complementary colors are great neutralizers. To mute ultramarine blue, add a small amount of cadmium orange.

Creating Specific Blues

You can easily mix a cerulean blue (sometimes called "sky blue") with basic colors in your palette. Simply blend ultramarine with touches of cadmium yellow and titanium white.

To achieve a light, cool, yellow-leaning blue, you can use cobalt turquoise acrylic from the tube. However, you can also mix this hue using phthalo blue (green shade), cadmium yellow, and titanium white. Add more titanium white for a beautiful range of pastels.

Painting with Blues

In this acrylic painting on canvas panel, I used turquoise blues alongside warmer ultramarine mixes. By dominating the painting with blues, I create a sense of depth, serenity, and atmosphere. I punctuate the foreground with warm reds and oranges to emphasize the distance of the mountain.

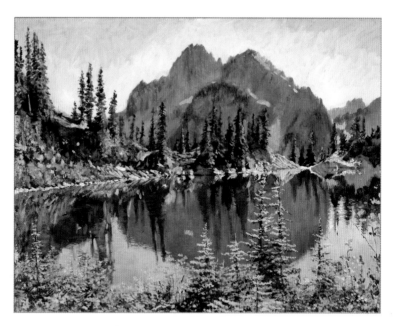

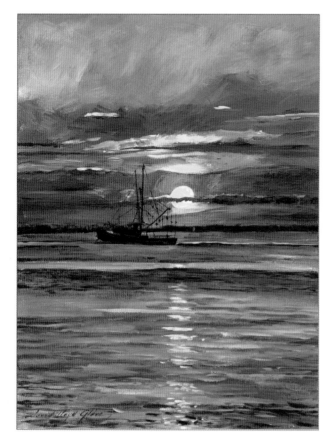

Dominated by warm blues, this sunset contains ultramarine, phthalo blue, dioxazine purple, cadmium yellow, primary red, and titanium white. The complementary bright yellows and oranges of the sun and surrounding clouds make the warm blues appear even more intense to the eye. I included areas and strokes of cool blues as well for more dimension.

Samples of Blue Mixes

Below is a selection of mixes that are helpful when working with blues. Each mix is accompanied by a "recipe," allowing you to re-create any swatch desired. To create the color samples, I used titanium white for "white."

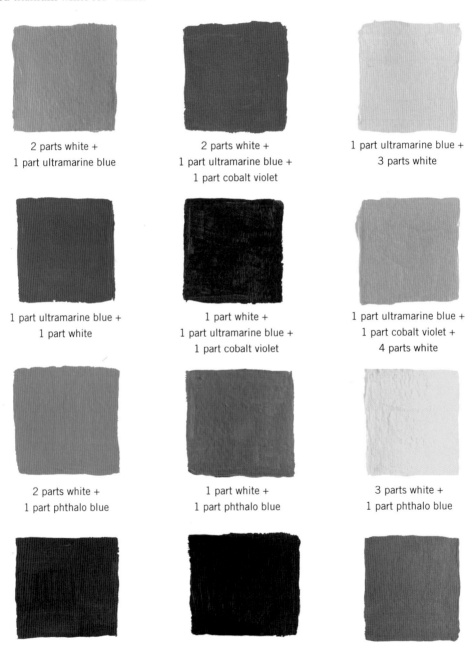

2 parts white +
1 part ultramarine blue

2 parts white +
1 part ultramarine blue +
1 part cobalt violet

1 part ultramarine blue +
3 parts white

1 part ultramarine blue +
1 part white

1 part white +
1 part ultramarine blue +
1 part cobalt violet

1 part ultramarine blue +
1 part cobalt violet +
4 parts white

2 parts white +
1 part phthalo blue

1 part white +
1 part phthalo blue

3 parts white +
1 part phthalo blue

2 parts white +
1 part ultramarine blue +
1 part cobalt violet

1 part white +
1 part phthalo blue +
1 part dioxazine purple

2 parts white +
1 part phthalo blue +
1 part dioxazine purple

Working with Secondaries

Secondary colors add dimension to the color wheel with three festive hue families—violet, green, and orange. Each of these colors is a mix of two primary colors. Violet is a combination of red and blue, green is a combination of blue and yellow, and orange is a combination of yellow and red. In this section, you'll discover information on working with secondary pigments, as well as manipulating your mixes to achieve a wide range of tones and hues. Each section concludes with finished works showcasing the use of a particular secondary.

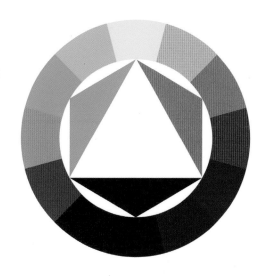

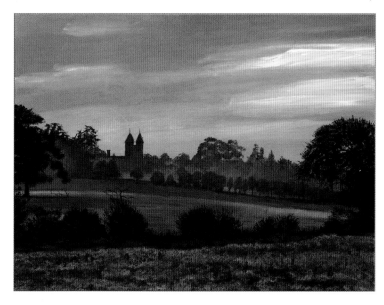

Like primaries, secondaries form a triadic color scheme when used together in a painting. Lying equidistant on the color wheel, each color helps bring out the others in this scene, and together they allow for dusky tones that still retain impact.

Working with Greens

Green is a fresh, cool-leaning color that suggests fertility and nature, ranging from deep, earthy tones to the bright greens of spring. On the following pages, learn about available pigments and how to manipulate this color to suit your artistic needs.

> *The paints below are common paint colors shown in masstone (with thickness), undertone (spread thinly), and mixed with white. Note that every paint color varies somewhat between manufacturers.*

Common Green Pigments

Phthalo green is a cool, blue-leaning green in the phthalocyanine family. It is transparent and highly staining with a strong tinting ability. Like phthalo blue, it has a dark masstone but a vibrant undertone. *Alternatives/other names: phthalocyanine green*

Moss green, which is similar to sap green, has a vibrant, orange-leaning undertone. This color is a wonderful tool for painting foliage. Deepen it with a trace of red or blue, and brighten it with cadmium lemon yellow and white.

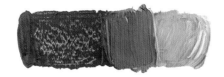

Chromium oxide green is cool, earthy, muted, and very opaque. This color is a favorite choice among landscape artists. *Alternatives/other names: chromium sesquioxide*

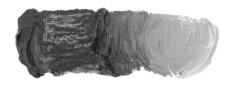

A true middle-green in masstone, cobalt green is a vibrant, blue-leaning green pigment. It can serve as a low-tinting alternative to phthalo green. *Alternatives/other names: cobalt green hue*

Other Green Paints

Viridian green: This cool, blue-leaning green is transparent with a low-staining quality.

Sap green: This yellow-leaning paint is a warm, earthy green made from a mix of yellow and blue pigments, leading to variability in properties between manufacturers.

Hooker's green: This warm, medium green is a mixture of Prussian blue and gamboge.

Common Greens Mixed from Primaries

For the garden and landscape painter, mixing greens is a crucial part of the artistic process. Trees, bushes, plants, shrubs, leaves, petals, and grasses all call for some form of green. Even if you choose to work with premixed green paints from the tube, such as Hooker's or sap green, you'll need to modify them to create the many hues that exist in a natural-looking landscape painting.

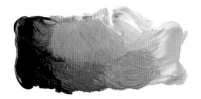

Phthalo blue (green shade), titanium white, and cadmium yellow mixes produce greens that resemble the hues of phthalo green, yielding clean and bright mixes.

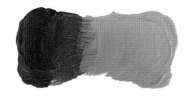

Ultramarine blue blended with cadmium yellow dark (in a 1:1 ratio) creates a dull, earthy green that resembles Hooker's green. Deepen it with traces of Payne's gray.

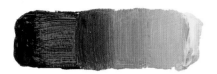

Ultramarine blue blended with cadmium yellow light (in a 1:1 ratio) creates a bright green that resembles cobalt green.

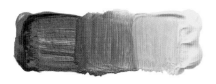

Cerulean blue blended with cadmium yellow light (in a 1:1 ratio) creates a rich middle-green similar to a cadmium green.

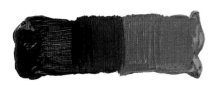

Phthalo blue (green shade) blended with yellow ochre (in a 1:1 ratio) creates a range of deep greens that resemble chromium oxide green or sap green.

Artist's Tip

For most colors on the wheel, pushing a mix toward red warms the color, and pushing a mix toward blue cools it. Green, however, is the complement of red, so pushing a green toward red can neutralize and take away the vibrancy of the hue. Therefore, it is generally considered that warm greens lean yellow and cool greens lean blue.

Warming Greens

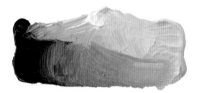

Mixing phthalo green with titanium white yields cool teal tints. Adding cadmium yellow creates warm, bright spring greens.

In this example, I blended cadmium yellow dark into Hooker's green to create warmer, lighter greens. This combination makes for versatile shades of green in natural landscape paintings.

Cooling Greens

To create a range of cool but vibrant blue-greens, consider mixing in a warm blue such as cerulean. In this example, I created a simple green mix of ultramarine blue and cadmium lemon yellow (far left) and cooled it with increasing amounts of cerulean blue (near left).

To cool and deepen phthalo green, add Payne's gray. This paint harmonizes beautifully with the cool green; mix in white for soft, muted variations.

Neutralizing Greens

Phthalo green mixed with its complement, cadmium red, yields deep greens and reds. Red-toned greens and rich browns are essential in landscape painting.

In this example, I neutralized Hooker's green with crimson red for deep, muted tones. I added a touch of zinc white to cool and lighten the mix.

Working with Green Gold

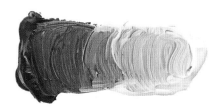

Similar to sap green, green gold is a warm, golden green with hints of olive. It has a very natural, leafy feel that is often an effective choice when rendering foliage.

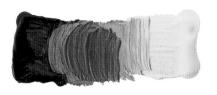

To mix your own green gold with a basic palette, mix ultramarine blue with cadmium yellow; then add a very small amount of cadmium red for warmth.

Create another warm, muted green by mixing ultramarine blue with cadmium yellow dark and titanium white.

Painting with Green

To make a primarily green painting appear colorful yet realistic, make sure your greens vary in temperature and tone. Use warm greens alongside cooler shades to establish dimension and visual interest. In this painting of a garden arbor trellis, the play of light and shadow creates a mix of cool shadows and warm, illuminated foliage.

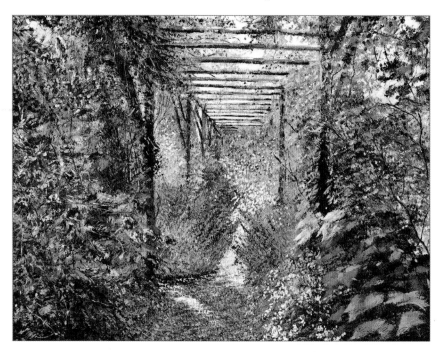

This midday summer garden utilizes an almost entirely green palette. Even the darkest shadows are deeply neutralized greens. The sky is Monet's favorite—cerulean blue—but even this blue leans heavily toward green. Red, orange, and violet flowers stand out as colorful accents against the warm greens of the scene.

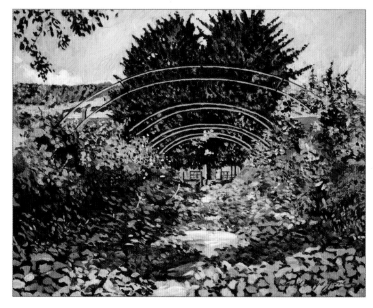

Samples of Green Mixes

Below is a selection of mixes that are helpful when working with greens. Each mix is accompanied by a "recipe," allowing you to re-create any swatch desired. To create the color samples, I used titanium white for "white."

3 parts white +
1 part phthalo green

1 part phthalo green +
3 parts white +
2 parts lemon yellow

2 parts cadmium yellow dark +
2 parts white +
1 part phthalo green

2 parts white +
1 part phthalo green

1 part lemon yellow +
1 part white +
1 part phthalo green

1 part cadmium yellow dark +
1 part phthalo green

1 part white +
1 part phthalo green

2 parts lemon yellow +
1 part white +
1 part phthalo green

1 part cadmium yellow dark +
1 part phthalo green

1 part white +
1 part phthalo green +
2 parts ultramarine blue

2 parts lemon yellow +
2 parts phthalo green +
1 part ultramarine blue

1 part cadmium yellow dark +
1 part phthalo green +
1 part ultramarine blue

Working with Violets

Violet is the darkest hue on the wheel and is quite versatile in its associations; its deepest, richest forms suggest royalty and strength, whereas its lightest tints and muted tones appear dreamy and feminine. On the following pages, learn about available pigments and how to manipulate this color to suit your artistic needs.

> *The paints below are common paint colors shown in masstone (with thickness), undertone (spread thinly), and mixed with white. Note that every paint color varies somewhat between manufacturers.*

Common Violet Pigments

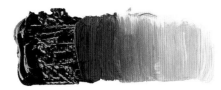

Dioxazine purple is a cool, transparent, staining pigment that is one of the strongest tinters of all artist pigments. It has a very dark masstone and an intensely vibrant undertone.

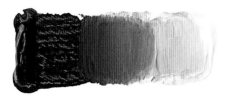

Cobalt violet is a popular and versatile medium-violet pigment that creates soft, muted tints. It is semi-transparent and moderate-to-low staining.
Alternatives/other names: cobalt violet hue

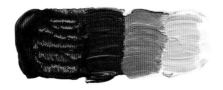

Quinacridone magenta is on the cusp of the purple family near red. Resembling the hue of magenta ink used in commercial printing, this paint is staining and transparent.

Other Violet Paints

Perylene violet: This staining and semi-transparent pigment is deep, earthy, muted, and almost brown in hue.

Quinacridone violet: This deep, warm, red-leaning violet is transparent and staining with an intense undertone. It is very similar in hue to quinacridone magenta.

Mixing Violet from Primaries

Cadmium red medium mixed with ultramarine blue creates a rich violet. Mix in more blue or red to push the violet cooler or warmer, respectively.

Warming Violets

In general, pushing a violet toward red yields a warmer hue. Cobalt violet and quinacridone magenta mix to create a warm, slightly muted, red-leaning violet.

Cooling Violets

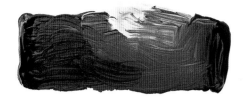

Mixing dioxazine purple with ultramarine blue cools the violet into rich, glowing tones.

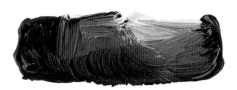

Mixing dioxazine purple with phthalo blue (green shade) creates deep and complex, cool tones of purple.

Artist's Tip

I find that dioxazine purple is a versatile mixing tool, which I often use to deepen colors in place of black. I advise you to use this pigment with some restraint, as it can quickly overpower a mix.

Neutralizing Violets

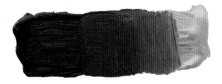

As purple's complement, yellow is an effective way to neutralize purple. Yellow and purple are the lightest and darkest colors on the wheel (respectively), so adding yellow also lightens the overall value of a purple mix. In this example, deep violet blends with cadmium yellow dark to create orange-leaning browns.

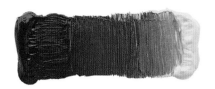

Cobalt violet neutralized with cadmium lemon yellow creates a brownish purple with a red-leaning cast.

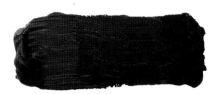

Mixing Payne's gray into deep violet yields a rich claret-wine color. Although deep violet contains a strong pigment, remember to use Payne's gray sparingly as it can quickly overpower a mix.

Mixing quinacridone magenta with Payne's gray creates a neutralized color that resembles a deep burgundy. Payne's gray has an almost blueberry-juice stain to it, so adding it to magenta pushes the mix toward blue.

Although not a complementary color, you can still use green to neutralize colors in the purple family. In this example, view how green gold mutes cobalt violet into a deep, red-leaning neutral purple.

You can neutralize dioxazine purple with cobalt green to produce rich, deep shades. Mixing them in a ratio of 1:1 leaves the pigment-rich purple as the dominant color.

Painting with Violets

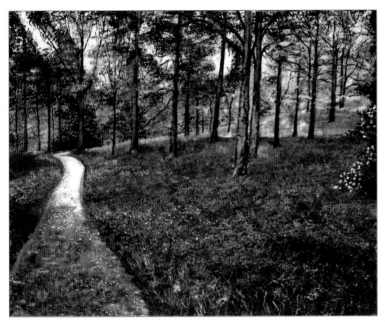

In this painting of wildflowers in a park, I created depth and dimension by incorporating a variety of purples. The warm and cool purples work together to excite the eye as they suggest light and shadow. I used dioxazine purple for the deepest colors, cobalt violet for the highlights, and ultramarine blue to deepen and shape the flower clusters. For the softer tints of purple in the distance, I mixed in more titanium white.

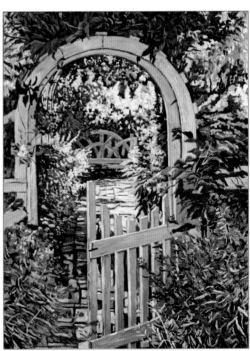

In this garden painting, I infused color into a white fence, arbor, and gate by using tints and tones of purple. The subtle purples enhance the warm, glowing complementary yellows of the scene to give the impression of sunlight filtered by leaves.

Samples of Violet Mixes

Below is a selection of mixes that are helpful when working with violets. Each mix is accompanied by a "recipe," allowing you to re-create any swatch desired. To create the color samples, I used titanium white for "white" and phthalo blue (green shade) for "phthalo blue."

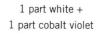

1 part quinacridone magenta +
1 part cobalt violet +
1 part white

1 part white +
1 part cobalt violet

2 parts white +
1 part dioxazine purple

2 parts cobalt violet +
1 part cadmium red medium +
1 part white

2 parts phthalo blue +
1 part medium violet +
1 part white

2 parts white +
2 parts dioxazine purple +
1 part ultramarine blue

2 parts white +
1 part dioxazine purple +
1 part ultramarine blue

1 part quinacridone magenta +
1 part white

2 parts cobalt violet +
1 part cadmium red medium

2 parts cobalt violet +
2 parts white +
1 part cadmium red medium

1 part quinacridone magenta +
1 part phthalo blue

2 parts phthalo blue +
1 part dioxazine purple +
1 part white

48

Working with Oranges

Orange is a bold, warm, and invigorating color often associated with fire and autumn. Its hues can be deep and fiery or pale and delicate, like apricots or light skin tones. On the following pages, learn about available pigments and how to manipulate this color to suit your artistic needs.

The paints below are common paint colors shown in masstone (with thickness), undertone (spread thinly), and mixed with white. Note that every paint color varies somewhat between manufacturers.

Cadmium orange is a premixed paint color of cadmium red and cadmium yellow pigments. This opaque and low-staining paint is a balanced orange with a yellow-leaning undertone.
Alternatives/other names: cadmium orange hue

Perinone orange is an intense, red-leaning orange that thins to produce beautiful, transparent washes that are excellent for florals or skin-tone mixes.

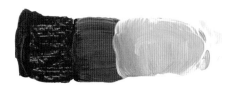

Quinacridone burnt orange is a transparent, deep, rich orange that resembles a neutral reddish brown. Blended with white, this paint yields earthy pink tones.

Other Orange Paints

Quinacridone gold: This is a transparent, low-staining, yellow-leaning orange. Nearly brown in color, this paint offers a great alternative to raw sienna.

Warming Orange

Warming an orange involves pushing it toward the red side of the color wheel. To effectively warm cadmium orange, simply mix in small amounts of cadmium red.

Cooling Orange

Push an orange toward yellow for a cooling effect. Add cadmium lemon yellow (a cool, green-leaning yellow) to cool cadmium orange.

Neutralizing Oranges

You can dull orange using a dab of its complement, violet. In this example, cobalt violet mutes and deepens cadmium orange.

Creating Skin Tones

There are no hard-and-fast rules when it comes to mixing skin tones. There are so many factors to consider, from texture and color to ethnicity, age, and gender. The environment is also an important consideration, as skin will reflect surrounding colors and light. Below are a few mixing samples to help you get started.

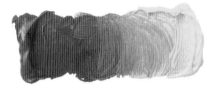

A good base for a common pale skin tone includes cadmium orange, dioxazine purple, and titanium white.

For skin-tone shadows, I again use cadmium orange and dioxazine purple, but I include less white in the mixture.

Rosier skin tones, especially lip and cheek areas, call for mixes of cadmium orange, titanium white, and quinacridone magenta.

Create cool skin tones using cadmium orange, phthalo blue (green shade), and white.

Create warm skin tones using cadmium orange, cadmium yellow, and white.

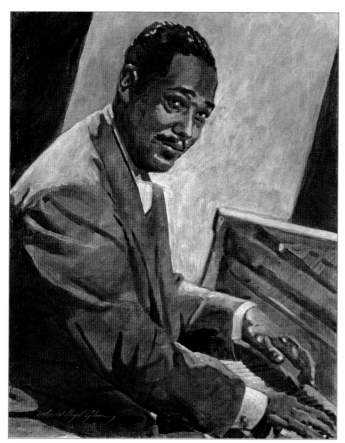

This portrait of Duke Ellington was inspired by his 1927 composition "Black and Tan Fantasy." I restricted my palette to neutral tan and black tones, accenting with muted oranges for warmth and dioxazine purple for cool, colorful shadows. The result is a unified, warmly lit nightclub scene that resembles a sepia-toned photograph.

Painting with Oranges

In this palette knife painting, I used a wide range of oranges to suggest the landscape. For a vibrant visual dynamic, I used a complementary blue in the sky. I also accented the tree with dabs of bright green to complement the deep red-oranges of the tree.

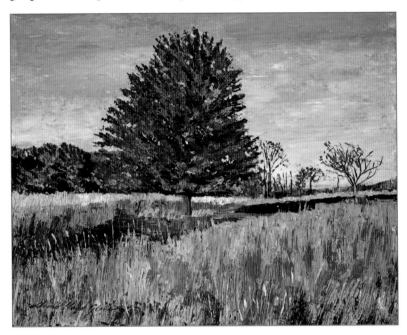

Although orange hues cover the majority of this autumnal scene, they take on a supporting role as the complementary yellow of the center tree and purple of the road serve as the areas of focus.

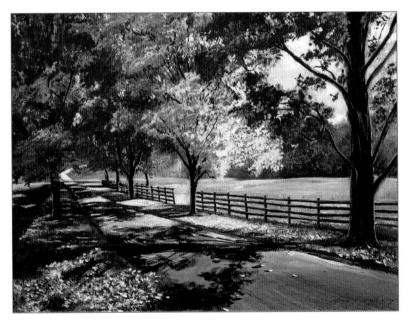

Samples of Orange Mixes

Below is a selection of mixes that are helpful when working with oranges. Each mix is accompanied by a "recipe," allowing you to re-create any swatch desired. To create the color samples, I used titanium white for "white."

3 parts white +
1 part cadmium orange

2 parts white +
1 part cadmium orange +
1 part lemon yellow

1 part cadmium orange +
1 part cadmium yellow medium

2 parts white +
1 part cadmium orange

2 parts white +
1 part cadmium yellow dark +
1 part cadmium orange

1 part cadmium yellow dark +
1 part cadmium orange

1 part cadmium orange +
1 part cadmium yellow medium +
1 part cadmium red medium

1 part cadmium orange +
1 part cadmium yellow medium +
1 part cadmium red medium +
1 part cobalt violet

1 part cadmium orange +
1 part cadmium yellow dark +
1 part cadmium red medium +
1 part cobalt violet

1 part cadmium yellow medium +
1 part cadmium red medium +
1 part cadmium orange

1 part cadmium orange +
1 part quinacridone magenta

1 part cadmium orange +
1 part crimson red +
trace of cobalt violet

Working with Neutrals

Neutrals encompass browns, grays, and a range of muted tints, tones, and shades. Pure hues, such as blue or green, tend to receive more attention, but neutrals are in fact more prominent in our day-to-day lives. They are easy on the eyes—soft, soothing, and atmospheric—and they can serve to help pure hues appear more vibrant.

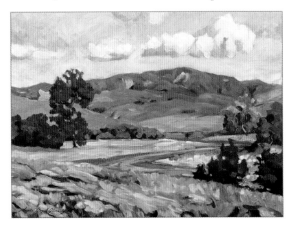

▶ The muted colors of this classic landscape suggest a light, airy atmosphere. Although the mind still reads some areas as vivid color, such as the complementary reddish brown tree and green bushes, I softened and neutralized all the colors in the painting for a unified, subtle appearance.

Mixing Neutrals

Neutrals are blends of all three primaries: red, yellow, and blue—plus white when desired for softening and lightening. To create neutrals that lean warm or cool, simply adjust the proportions of your pigments. Red- and orange-leaning neutrals appear much warmer than blue- or green-leaning neutrals. Experiment with the pigments on your palette to discover the wide range of neutrals at your fingertips.

Cadmium red medium, cadmium yellow medium, and ultramarine blue combine to create a range of rich neutrals.

Using the same primary colors, add white for a range of softer tones. Add more blue for darker, cooler mixes, and add more yellow and white for lighter mixes.

For a warm brown, try mixing red and yellow with just a touch of blue in the bristles.

In this example, the top mix contains more yellow, whereas the bottom mix contains more red.

For cool browns and grays, blend yellow, blue, and white with just a touch of red in the bristles.

Working with Browns

Browns are earthy mixes of the three primary colors in varying proportions. Tints, tones, and shades of brown can range from pale tans and ruddy terra-cottas to deep chocolates and rich skin tones. Although browns do not have a place on the traditional color wheel, they play an important role in painting. Just look around you; in real life, browns are some of the most ubiquitous tones visible to the eye. On the following pages, learn about available pigments and how to manipulate this color to suit your artistic needs.

The paints below are common paint colors shown in masstone (with thickness), undertone (spread thinly), and mixed with white. Note that every paint color varies somewhat between manufacturers.

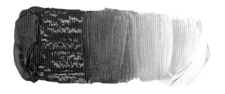

Raw umber is a cool, muted brown that is transparent and low staining.

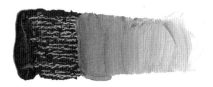

Burnt umber is a warm, muted, red-leaning brown that is transparent and low staining.

Raw sienna is a yellow-leaning brown with a golden undertone. It is transparent and low staining.

Burnt sienna is a warm, red-leaning brown that is transparent and low staining.

Warming Browns

You can warm browns by pushing the mix toward red. In this example, burnt umber mixed with cadmium red yields warm, rich, muted tones.

To warm a brown without deepening the color, consider adding orange instead of red. In this example, I warm and brighten burnt umber using cadmium orange.

Cooling Browns

Cooling a brown involves pushing it toward blue on the color wheel. In this example, raw umber mixed with ultramarine blue yields lively gray tones.

Muting Browns

Muting an intense brown calls for a neutralizer and a white. In this example, raw umber blended with zinc white and Payne's gray does the trick, graying the color down without affecting its value.

Neutralizing Browns

You can sometimes use brown as an effective neutralizer for other colors. In this example, I mute the intensity of moss green using raw umber, creating an earthy tone perfect for landscape painting.

Samples of Brown Mixes

Below is a selection of mixes that are helpful when working with browns. Each mix is accompanied by a "recipe," allowing you to re-create any swatch desired. To create the color samples, I used titanium white for "white."

3 parts yellow ochre +
1 part quinacridone magenta +
trace of dioxazine purple

2 parts yellow ochre +
1 part cadmium orange +
trace of dioxazine purple

1 part phthalo green +
4 parts cadmium orange

3 parts yellow ochre +
3 parts titanium white +
1 part quinacridone magenta +
trace of dioxazine purple

2 parts yellow ochre +
2 parts titanium white +
1 part cadmium orange +
trace of dioxazine purple

1 part phthalo green +
4 parts cadmium orange +
2 parts titanium white

3 parts cadmium orange +
1 part ultramarine blue

2 parts cadmium red medium +
1 part cadmium yellow dark +
trace of Payne's gray

2 parts lemon yellow +
1 part crimson +
1 part cerulean blue

3 parts cadmium orange +
1 part ultramarine blue +
2 parts titanium white

2 parts cadmium red medium +
3 parts titanium white +
1 part cadmium yellow dark +
trace of Payne's gray

2 parts lemon yellow +
1 part crimson +
1 part cerulean blue +
3 parts titanium white

Working with Black, White & Gray

Some artists create pieces using only black, white, and gray paint, resulting in monochromatic works of art that communicate simply and clearly with value. On the following pages, learn about available pigments and how to manipulate these colors to suit your artistic needs.

Black & Gray Pigments

Not considered a hue on the color wheel, black is just black—right? Not exactly. There are differences in appearance, consistency, and mixability among black pigments. It is easiest to see the differences in temperature and transparency by painting thinly, diluting the paint, or adding white. Some artists choose to avoid blacks and grays altogether by mixing them for a more natural look. (For more on mixing blacks, see page 60.)

> *The paints below are common paint colors shown in masstone (with thickness), undertone (spread thinly), and mixed with white. Note that every paint color varies somewhat between manufacturers.*

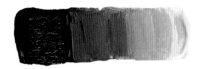

Lamp black is an opaque, warm black with strong staining properties.

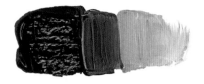

Ivory black is semi-transparent and moderately staining with a warm undertone.

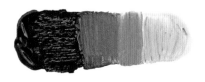

Mars black is cool and opaque. Of the black pigments, Mars is the strongest stainer.

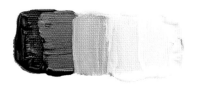

Payne's gray can be an effective substitute for black in your paintings if you want to neutralize a color without taking the life out of a mix. It is usually manufactured as a blend of ultramarine and gamboge pigments, although formulas vary among manufacturers. The blue undertone of Payne's gray creates a beautiful range of cool grays when mixed with white.

White Pigments

When painting with a traditional palette, white is the paint you will use most often; in fact, you will most likely use more white than any other color in your palette. The following cool white paints vary most distinctly in their transparency.

The paints below are common paint colors shown in masstone (with thickness), undertone (spread thinly), and mixed with black over a gray surface. Note that every paint color varies somewhat between manufacturers.

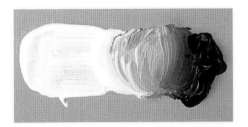

The most widely used white in acrylic is titanium white, which is a cool, opaque pigment. Titanium white mixed with ivory black creates flat, warm grays.

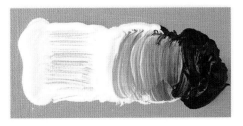

Zinc white (sometimes called Chinese white) is a cool, semi-opaque white. Zinc white mixed with Mars black creates cool grays.

Artist's Tip

The effects of mixing with white vary between colors. A small amount of white can bring out the intense hues of dioxazine purple, phthalo blue, or phthalo green. However, mixing white into warm colors (reds, oranges, and yellows) subdues the colors and makes them appear less vivid than straight from the tube.

Mixing Blacks

I don't use black pigment in most of my paintings. These pigments tend to look unnatural and flat set against the rest of my color palette. However, I do mix my own blacks (or deep, dark colors) to suit the overall color balance of a painting. Mixed blacks have a subtle sense of color and depth, which helps me create deep, lively shadows with dimension. Below are some of my favorite black mixes.

Mixing equal parts burnt sienna and ultramarine blue yields a dark, earthy black with a slight hint of blue.

Blending cadmium red medium with dioxazine purple yields a red-leaning black, which I often use to create tree branches and trunks.

You can create an effective cool black using cobalt violet and phthalo green. The more green in the mix, the deeper the color. I use this mix for my deepest ocean colors in seascapes.

Mixing equal parts cerulean blue and crimson red will give you a deep, purple-leaning black. As you add more red, the mix becomes more of a dark brown.

Artist's Tip

Using black to deepen or neutralize a color can overwhelm and deaden the other pigments in a mix. Remember, a little dab goes a long way.

Samples of Gray Mixes

Below is a selection of mixes that are helpful when working with grays. Each mix is accompanied by a "recipe," allowing you to re-create any swatch desired. To create the color samples, I used titanium white for "white" and phthalo blue (green shade) for "phthalo blue."

1 part cadmium orange +
2 parts phthalo green +
10 parts white

1 part cadmium orange +
2 parts phthalo blue +
2 parts Payne's gray +
20 parts white

1 part Payne's gray +
1 part cobalt violet +
1 part white

1 part yellow ochre +
2 parts white +
trace of phthalo green

2 parts cerulean blue +
1 part cadmium orange +
10 parts white

1 part Payne's gray +
1 part cobalt violet +
10 parts white

2 parts phthalo blue +
2 parts cadmium orange +
20 parts white

2 parts cerulean blue +
1 part Payne's gray +
8 parts white

1 part ultramarine blue +
1 part ivory black +
10 parts white

1 part phthalo blue +
2 parts cadmium orange +
10 parts white

1 part cadmium orange +
1 part Payne's gray +
8 parts white

1 part cadmium red medium +
2 parts phthalo green +
3 parts white

Painting with Neutrals

A bold scene with movement does not need a palette of bold colors. I painted this seascape using a mix of purple- and blue-leaning grays with an earthy brown foreground. The pure white establishes a bright, nearly shimmering focal point on the water.

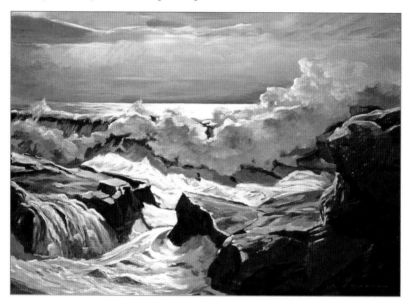

This painting is dominated by warm, reddish brown tones. Like many paintings full of neutral colors, the neutrals serve to guide the viewer's eye to the pure hues of the accent colors. In this case, the neutrals of the landscape enhance the yellows of the sky and the sunlit foreground.

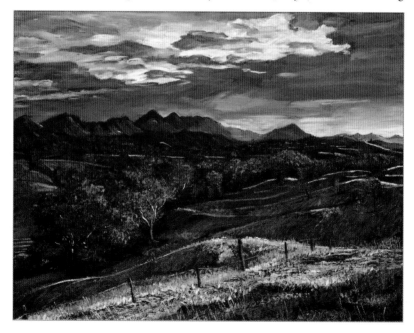

The soothing neutral tones in this piece pair well with the calm waters and stable verticals of the trees. The muted greens direct the viewer's eye to the complementary red of the focal point—the boat's interior. Set against a neutral palette, even a subtle, muted red can sing.

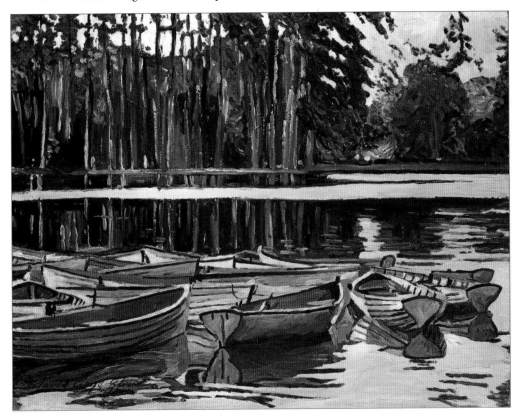

Closing Thoughts

As you develop your painting skills, you'll appreciate the basic laws of nature as they apply to color. They are often referred to as "color theory," but they may be better described as "color fact." As you begin to understand these basics, you can sharpen your ability to mix and re-create the colors you see around you, resulting in more effective paintings.

People who view my artwork most often comment on my use of color and the dynamic choices I make to bring a scene to life. Whether you use vivid hues or soft neutrals, your use of color contributes greatly to the success of a work of art, as well as the emotional impact on its viewers. For me, it is color that makes the painting process worthwhile.

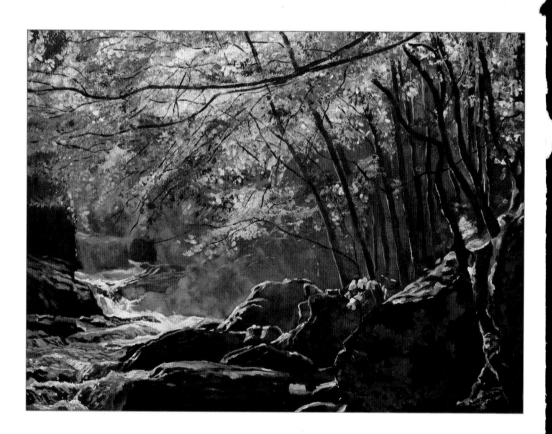